WARRINGTON

HISTORY TOUR

ACKNOWLEDGEMENTS

This book would not have been possible without the work of countless photographers who have recorded the town's changing landscape and every effort has been made to trace the copyright holders. Thanks are also due to the staff of Culture Warrington from the museum and archives sections who document the town's history for present and future generations.

First published 2018

Amberley Publishing
The Hill, Stroud,
Gloucestershire, GL5 4EP
www.amberley-books.com

Copyright © Janice Hayes, 2018
Map contains Ordnance Survey data
© Crown copyright and database right
[2018]

The right of Janice Hayes to be
identified as the Author of this work
has been asserted in accordance with
the Copyrights, Designs and Patents
Act 1988.

ISBN 978 1 4456 7933 4 (print)
ISBN 978 1 4456 7934 1 (ebook)

British Library Cataloguing in
Publication Data.
A catalogue record for this book is
available from the British Library.

Origination by Amberley Publishing.
Printed in Great Britain.

INTRODUCTION

Warrington today is an historic town poised on the brink of becoming a twenty-first-century city. Life appears to have changed almost beyond recognition since Warrington's designation as a new town in 1968 and its relocation to Cheshire as a result of local government reform of 1974. The town's population has effectively trebled with the creation of new communities and the addition of parts of old Lancashire and Cheshire districts, which were brought within the old borough boundaries. Warrington's long history as a Lancashire industrial town also came to an end with the nationwide decline of heavy industries, which were replaced by business parks and service industries brought by Warrington's unrivalled links to the national transport networks.

For older generations of Warringtonians daily life has also changed almost beyond recognition with the disappearance of traditional family-run businesses like butchers, grocers and corner shops. In their place are chain stores and supermarkets and out-of-town retail parks reached by a new local road network that swept away yet more familiar landmarks to satisfy the needs of the motorist.

This sense of change was just as vivid in 1908 when a local directory described Warrington as:

An enterprising and progressive town ... with unlimited scope for development. The town has altered considerably during the last few decades. Formerly it was a picturesque old-world place ... but the town still possesses many places of great antiquity.

Present-day Warrington has changed drastically since 1968 and that seems especially true in the town centre, where cranes dominate the skyline as another major redevelopment takes place. Yet clues to the town's past lie around every corner for the history detective and this local distinctiveness is an important part of Warrington's present and helps shape its future. The town centre is compact and can easily be explored in a series of short walks introduced by this history tour.

Warrington's location was a key factor in the town's development from the medieval village of Howley to the town centre that sprang up near to the bridge crossing over the River Mersey. At the heart of the town the main north–south and east–west regional roads crossed at a spot known as Market Gate, where the town's market was first held. Other street names provide clues to their origins – as the route to a place (e.g. Sankey Street) or their function, such as where the butter market was held or the names of former landowners such as Wilson Patten Street.

History detectives can find clues to the age of a building in the materials used in its construction, from the smaller half-timbered structures of the sixteenth century to the larger concrete and glass buildings of the last fifty years. However, some of the apparent Georgian and Victorian buildings you see may not be as old as you think. Look above your head for date stones or the initials of previous owners, especially in Bridge Street.

If you want to unlock more of the town's history then explore Warrington Museum's website or visit the Museum and Central Library building where the galleries have objects telling the story of Warrington. The archive section provides access to a wealth of resources from old maps and photographs to trade directories, local newspapers and histories of the town.

KEY

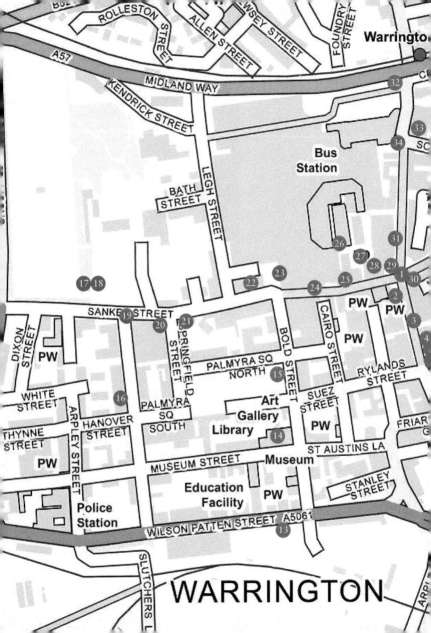

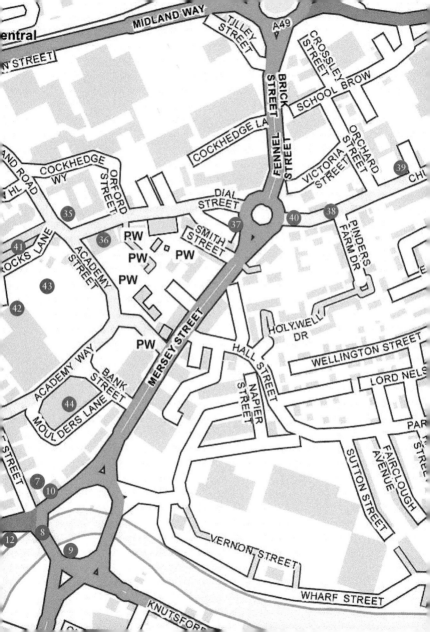

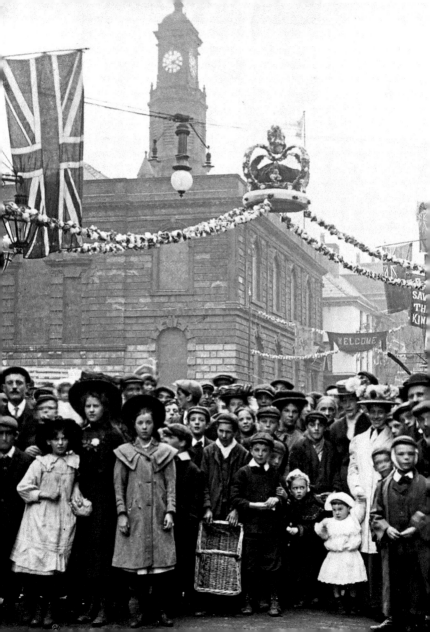

1. MARKET GATE

In 1913 an eager crowd waited at Market Gate to welcome George V on his route from Warrington Bridge to the Town Hall. This crossroads marked the spot where Bridge Street and Horsemarket Street led travellers north or south through the town to London or Scotland while Sankey Street and Buttermarket Street led them east or west to Liverpool or Manchester. Today's crowd would find it hard to recognise most of these street names or the buildings apart from the distinctive tower of Holy Trinity Church behind them in Sankey Street.

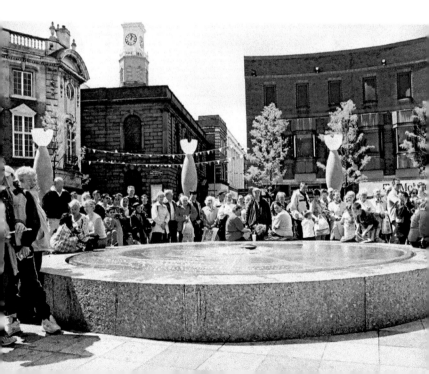

2. BOOTS CORNER, BRIDGE STREET

The widening of Market Gate began in the early 1900s but only the Bridge Street and Sankey Street corner was completed to the original vision by local architects Messrs Wright, Garnett and Wright, who envisaged four matching sectors of a circular design. For most of the century Warringtonians referred to this as Boots Corner after the chemist chain that occupied the site.

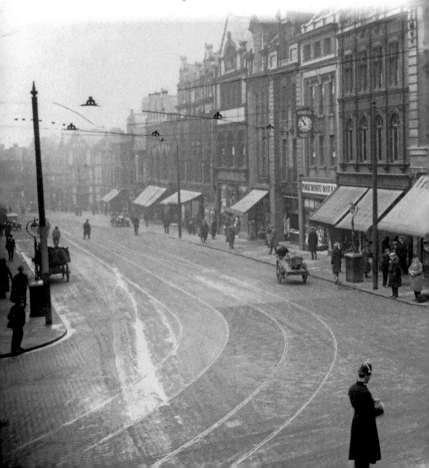

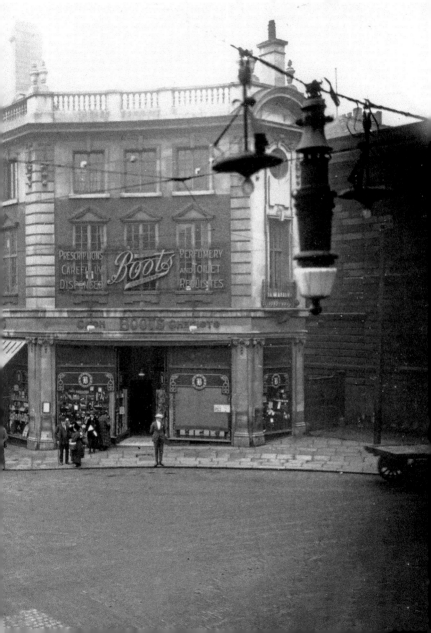

3. A WALK DOWN BRIDGE STREET

As the 1910 Walking Day procession neared Market Gate the widening of the west side of Bridge Street (on the right) was complete. Bridge Street today is full of history above the modern shopfronts. Each building is different; compare the materials and the decoration and look for date stones. The decorative shields high on the lampposts celebrate past lords of the manor of Warrington and local landowners.

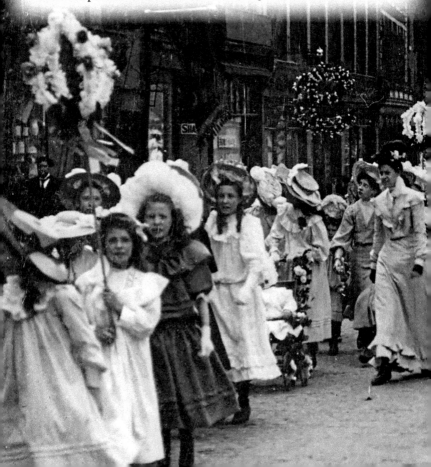

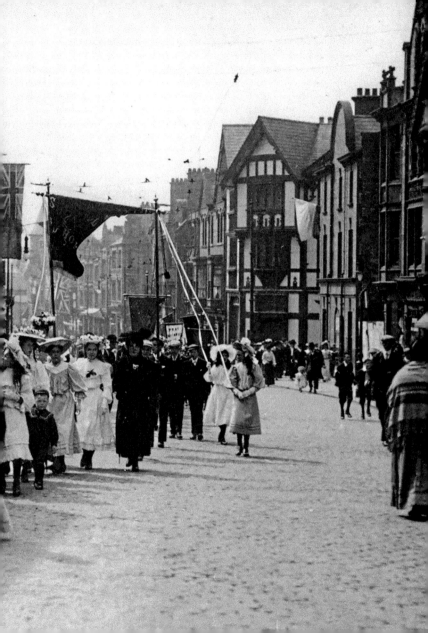

4. WIDENING BRIDGE STREET

Upper Bridge Street has changed considerably since the 1900s. This view towards Market Gate shows the emergence of today's familiar shopfronts built behind the line of the old narrow street on the left while the shops opposite await redevelopment.

5. BRIDGE STREET TO MARKET GATE

By 1910 the widening of Upper Bridge Street was complete and traffic was increasing with the new tram network.

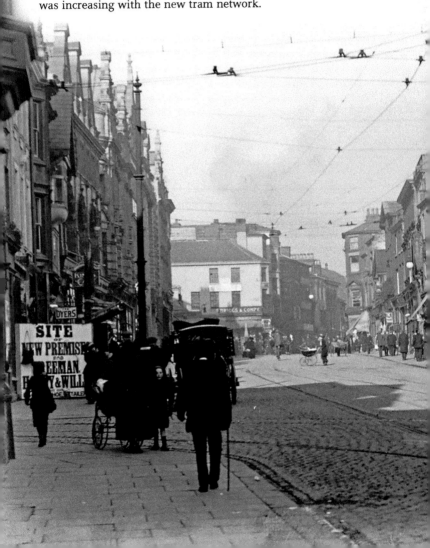

6. BRIDGE STREET, 2016

In 1996 the *River of Life* sculpture was unveiled in Bridge Street as a memorial to those killed and injured by the IRA bomb on 20 March 1993. By late 2017 the distinctive lion-topped Howard Building (right) was shrouded with protective scaffolding as work began to transform it as the frontage of Warrington's new market, scheduled for completion in 2020.

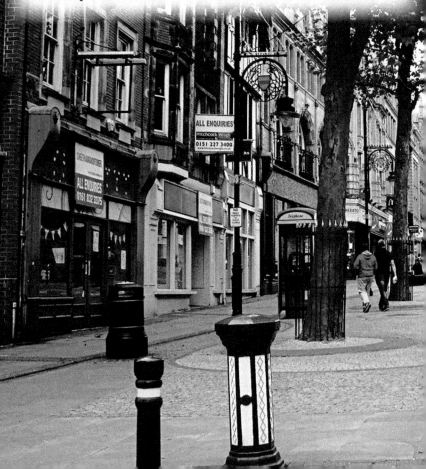

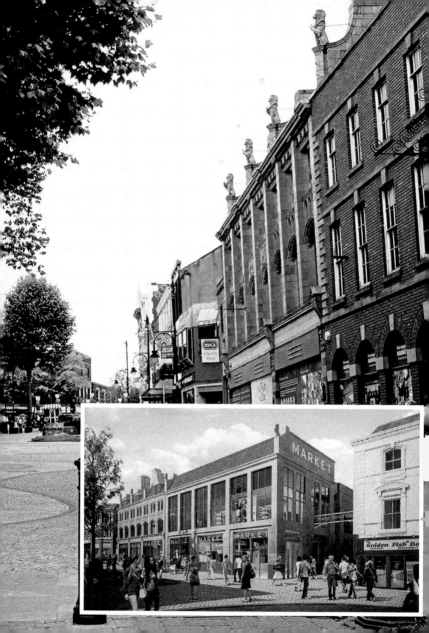

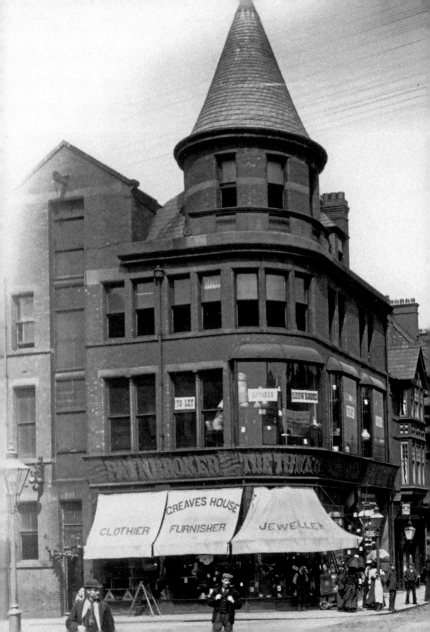

7. LOWER BRIDGE STREET

In the thirteenth century the Boteler family had built Warrington's first bridge as a route to their lucrative market and with it a new street, later appropriately known as Bridge Street. This early 1900s view shows the winding route to Market Gate and the distinctive Tower Buildings, which was demolished to make way for the relocation of the old Academy in 1918.

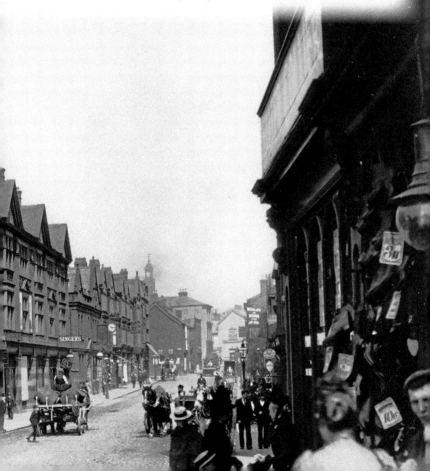

8. OLD WARRINGTON BRIDGE

By 1910 the narrow three-arched Victoria Bridge built in 1837 was already proving a traffic bottleneck. This view from Tower Buildings looking south to Knutsford Road is barely recognisable today. A much wider single-span reinforced concrete bridge, designed by local engineer John James Webster, was built between 1911 and 1915 with a second crossing added in the 1990s.

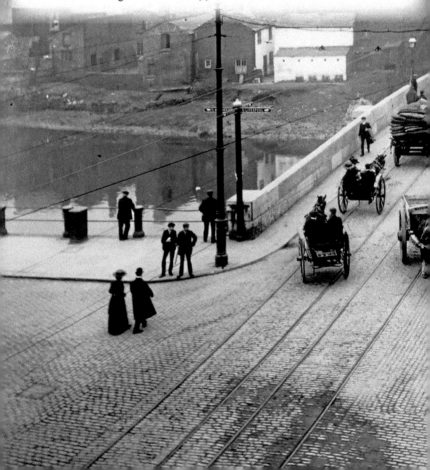

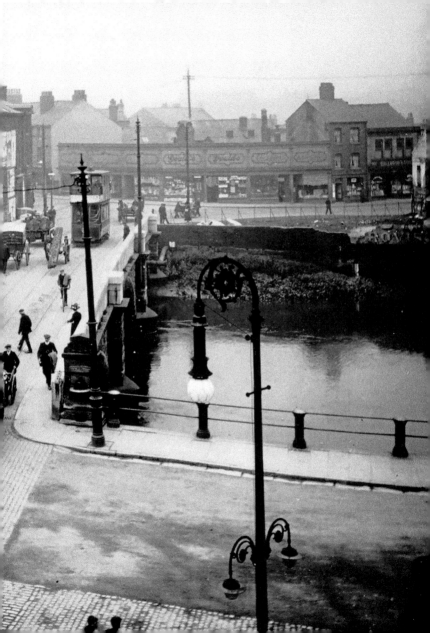

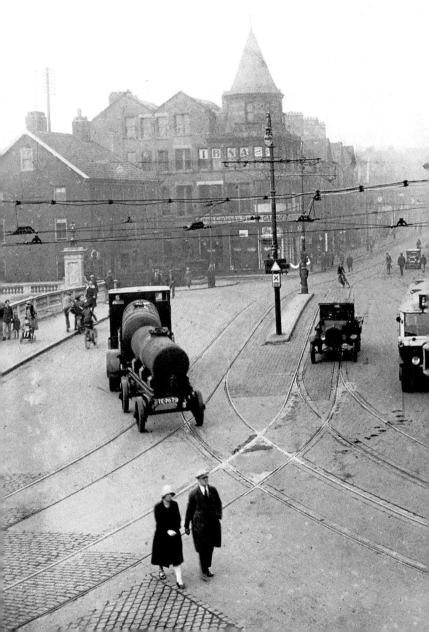

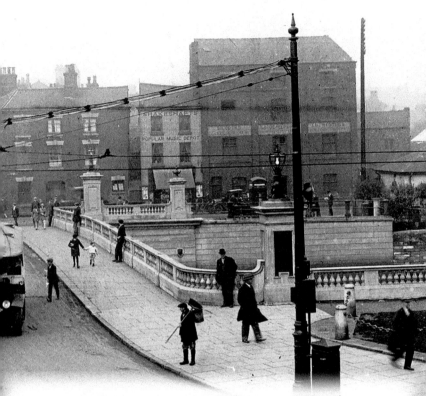

9. WARRINGTON BRIDGE, *c.* 1930

Warrington owes its regional importance to its river crossing but by the twenty-first century the ceaseless flow of traffic over Webster's bridge makes it difficult for pedestrians to admire its architecture and monuments. One of the pillars on the left of this view has a plaque recording the history of the site and just off to the right is Warrington's war memorial.

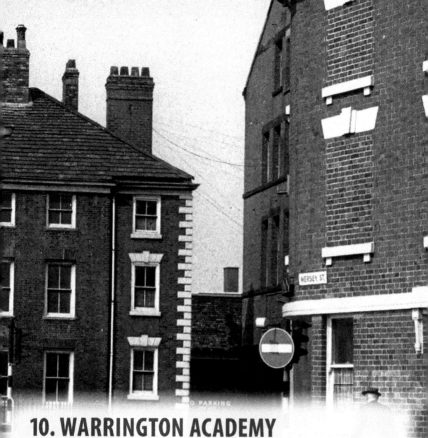

10. WARRINGTON ACADEMY

On 22 May 1981 a remarkable feat of civil engineering allowed the widening of Bridge Foot and apparently saved the historic Warrington Academy where acclaimed scientist Joseph Priestley had been a tutor. Contractors Pynford's sliced the building from its foundations and winched it to the adjacent site of the former Tower Buildings. Today's academy building, however, is a replica. Oliver Cromwell's statue now faces the Mersey and the ABC cinema in the background has also disappeared.

11. GOODBYE MR SMITH'S

In the early hours of 15 April 2015 fire swept through the former Mr Smith's nightclub at Bridge Foot. By the end of the day the building was deemed unsafe and the demolition of this well-loved art deco former Ritz and ABC cinema swiftly followed. While the future of the site is decided, it makes a quiet vantage point to look across to Warrington Bridge and Bridge Foot.

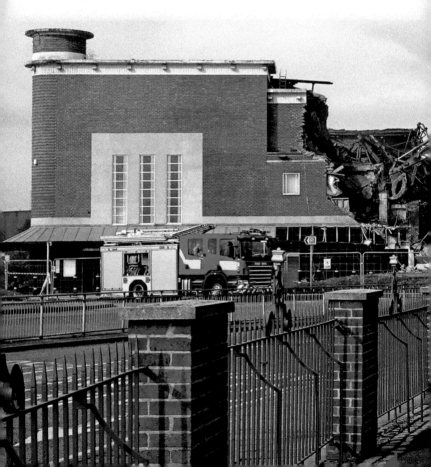

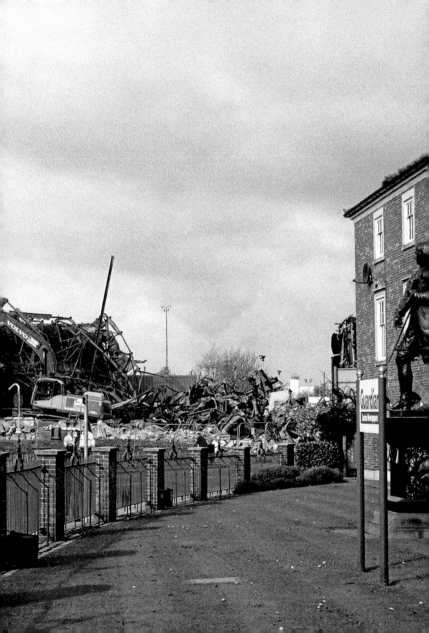

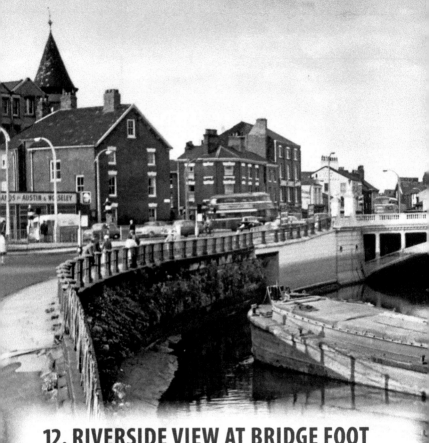

12. RIVERSIDE VIEW AT BRIDGE FOOT

By the nineteenth century the River Mersey was a major transport highway serving the town's industries. Although most activity was concentrated at Bank Quay, a second dock developed at Bishop's Wharf (seen behind the bridge) serving mainly local tanneries and paper mills. By the late 1950s many of the tanneries had closed and the riverboats soon disappeared. Today a new retail park has replaced the old warehouses.

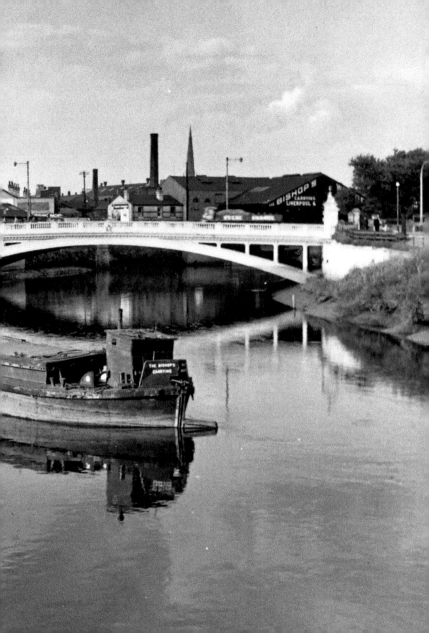

13. WILSON PATTEN STREET

In the early 1900s Wilson Patten Street was a quiet area of newly built middle-class villas, all protected behind ornate metal railings. Many of their inhabitants would soon relocate to the leafier suburbs south of the Manchester Ship Canal with the advent of the new public transport network. Today the road is clogged with traffic and homes have given way to offices.

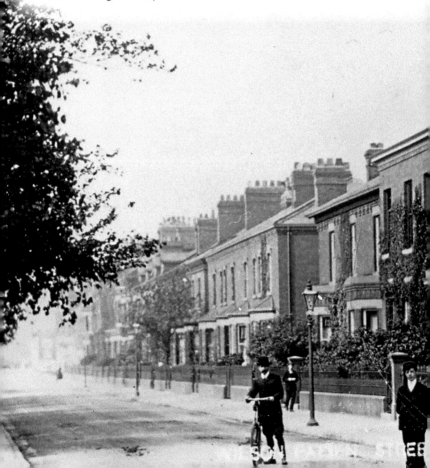

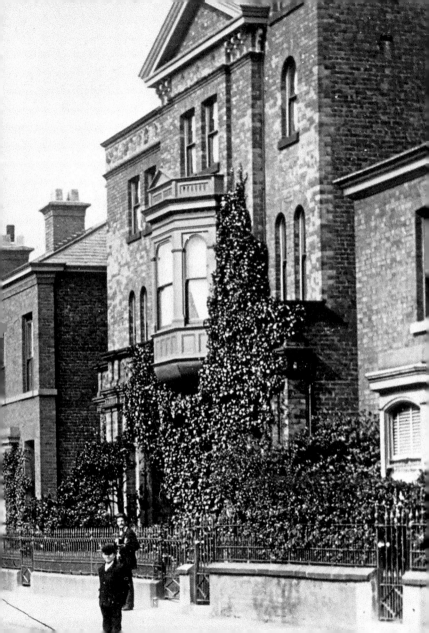

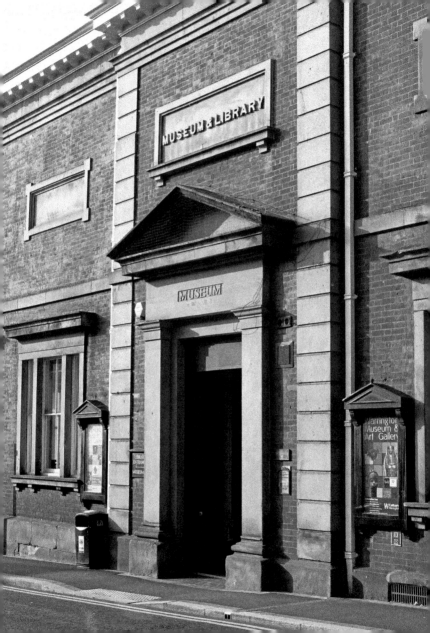

MUSEUM & LIBRARY

MUSEUM

Warrington
Museum &
Art Gallery

14. WARRINGTON MUSEUM

Founded in 1848, Warrington Museum was the third local authority museum to be created in the country and the first in the north-west of England. By 1853 the museum and its associated library had outgrown its rented premises in Friars Gate and the search began for a new home. Thanks to the generosity of local landowner Mr Wilson Patten a site was found off Bold Street to build a 'Home for the Muses', to make art, literature and science accessible to all. The foundation stone ceremony on 22 September 1855 was witnessed by a crowd of 2,000 people and recorded in this remarkable photograph (below). The building opened in 1857 and now provides a rich resource for those wanting to explore their cultural heritage and find clues to Warrington's past.

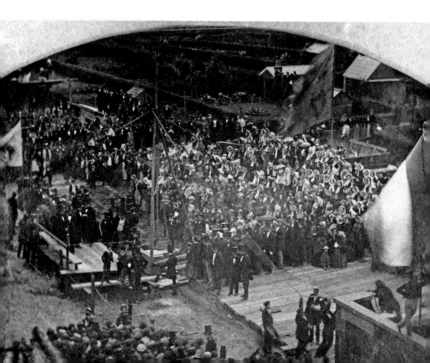

15. QUEEN'S GARDENS

The private gardens of the residents of Palmyra Square were purchased to celebrate the fiftieth anniversary of Warrington Borough Council and the Diamond Jubilee (or sixtieth anniversary) of Queen Victoria's reign in 1897. The statue of Lt Colonel McCarthy O'Leary was unveiled on 21 February 1907 to commemorate local men killed fighting in the South Lancashire Regiment in the Boer War in South Africa.

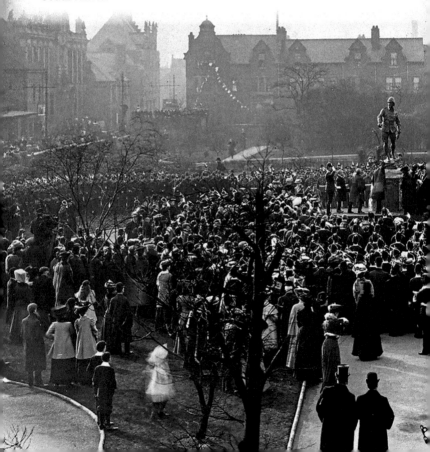

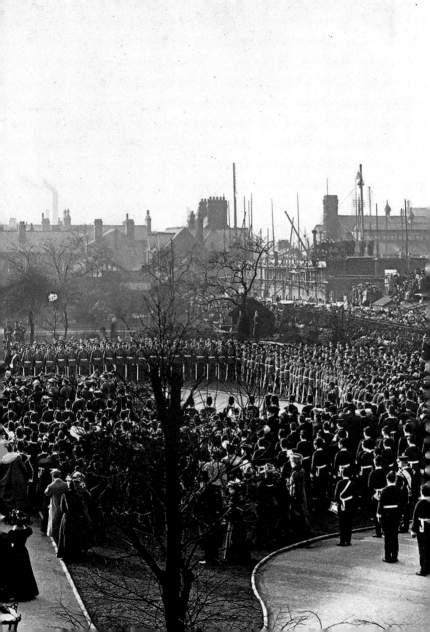

16. WINMARLEIGH STREET

By the 1900s bay-fronted villas has appeared on the fringes of the town centre to house the middle classes. Winmarleigh Street (named after the descendants of the Patten family) encroached on the Town Hall, which is half hidden behind its ornate gates and the bulky Walker Fountain in the background. New technology had arrived in the shape of the tower of masts on Warrington's first telephone exchange and the posts of the electric tram network.

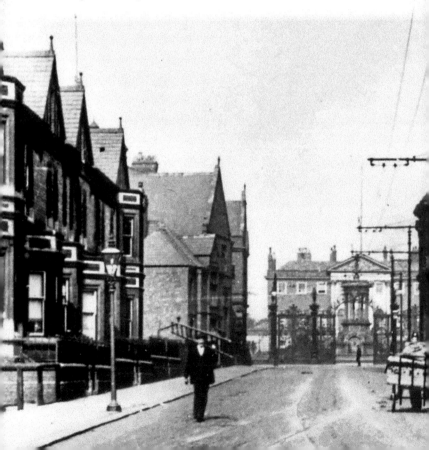

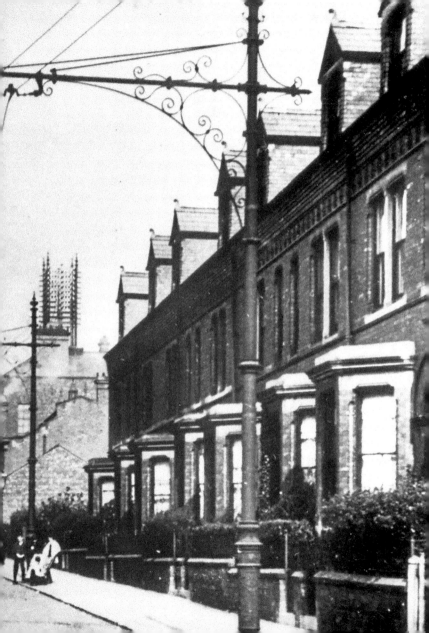

17. THE TOWN HALL AND GATES

Warrington's Town Hall was built in 1750 by world-famous architect James Gibbs as a home for local businessman and copper manufacturer Thomas Patten. By 1873 Patten's great-grandson, Colonel Wilson Patten, later Lord Winmarleigh, sold the building to Warrington Borough Council for £9,500. The family home became Warrington's new Town Hall and the grounds became known as Bank Park.

On Warrington Walking Day, Friday 28 June 1895, Councillor Frederick Monks of Monks Hall Iron Foundry presented these magnificent gates to the town (right). Originally designed by Coalbrookdale Ironworks to grace the royal house at Sandringham, they were adapted to have Warrington's coat of arms and later gilded to their intended design.

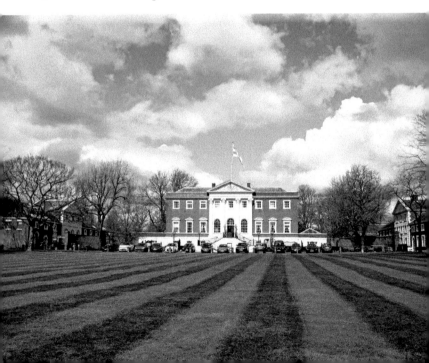

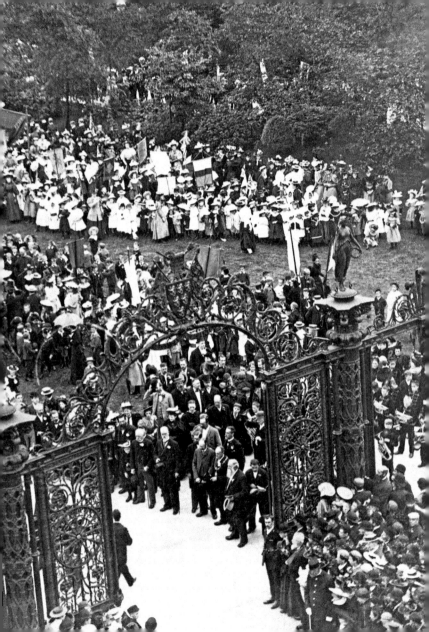

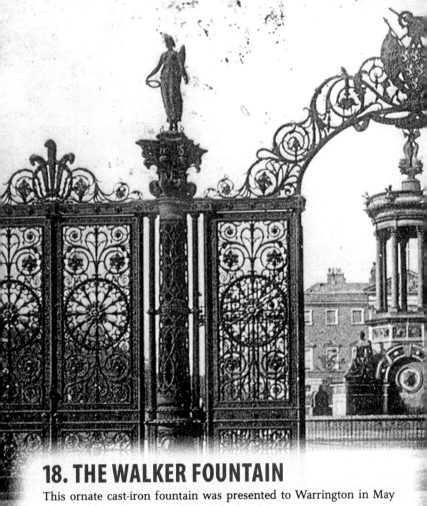

18. THE WALKER FOUNTAIN

This ornate cast-iron fountain was presented to Warrington in May 1900 in memory of Peter Walker of Walker's Brewery. Manufactured by McFarlane & Co. of Glasgow, it dominated the Town Hall and its gates and drenched passersby. It was demolished in March 1942 in a patriotic Second World War scrap metal salvage campaign.

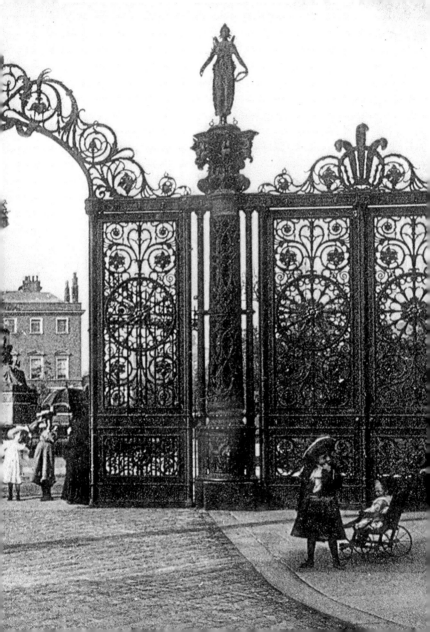

19. SANKEY STREET NEAR WINMARLEIGH STREET

The building on the near right was Warrington's first telephone exchange before it relocated to Wilson Patten Street in 1957. The ornate gable end of the central white block is a survivor of the impressive *Warrington Guardian* building, which graced the street from the early 1880s to the modernisation of 1973. The newspaper relocated to the remodelled academy building at Bridge Foot in the 1980s and later to Centre Park.

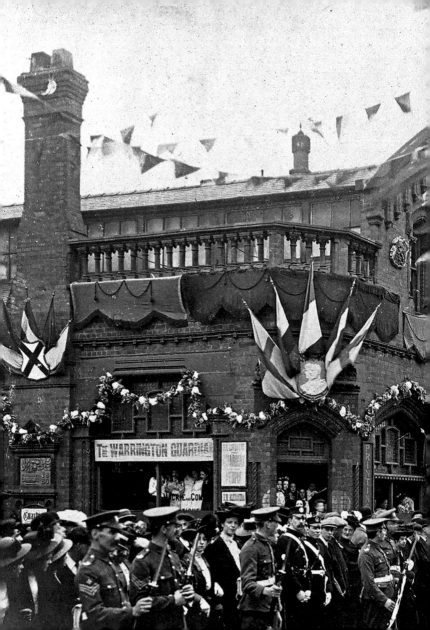

20. SPRINGFIELD STREET TO WINMARLEIGH STREET

In July 1909 these troops had a grandstand view outside the old *Warrington Guardian* office for the visit of Edward VII and Queen Alexandra. They had a long wait for the motorcade to arrive at the Town Hall, before leaving just four minutes later.

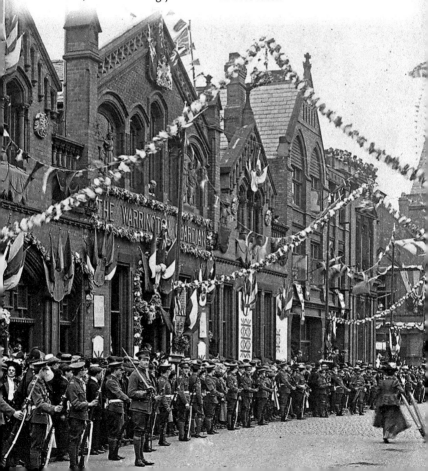

21. SANKEY STREET NEAR SPRINGFIELD STREET

Early twentieth-century Sankey Street had yet to become a busy traffic route. On the corner of Springfield Street (near right) was the ornate Picturedrome, known as the Cameo Cinema by the 1950s. In the background Eustance's clock was ticking away the time before the road widening of the mid-1920s.

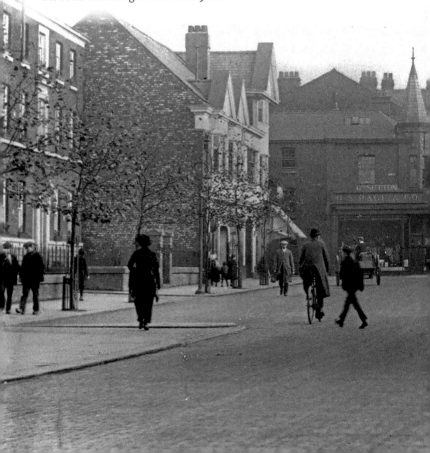

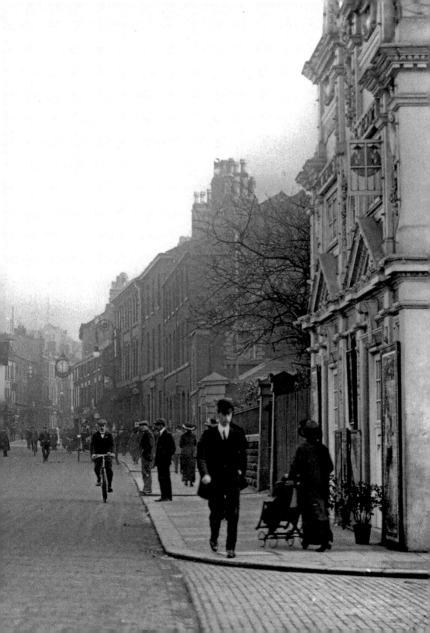

22. GOLDEN SQUARE AND SANKEY STREET

Today Sankey Street is pedestrianised from its junction with Bold Street and the view towards Market Gate is dominated by the modern buildings of Golden Square on the left. The buildings to the right date from the early nineteenth to twentieth centuries, including the distinctive tower of the former Co-operative store.

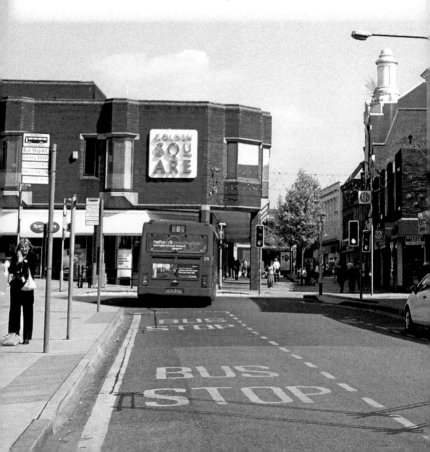

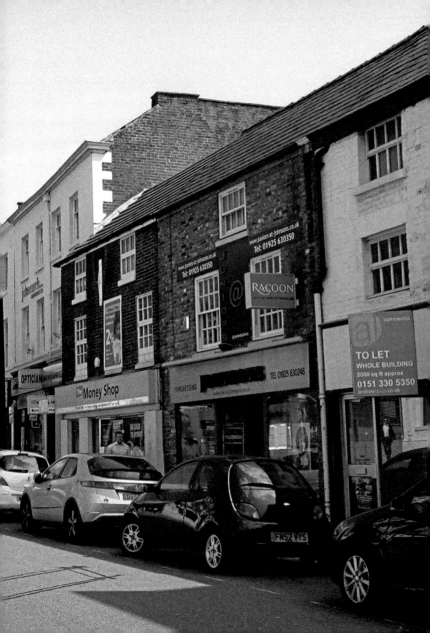

23. HILDEN PLATZ

Pedestrianisation of Sankey Street was made possible in the 1970s–80s by the construction of a new inner ring road, which diverted traffic via Golborne Street, across Horsemarket Street, Scotland Road and Academy Way to Bridge Foot. A multistorey car park was created in neighbouring Legh Street and a bus station off Golborne Street. By 2007 the Golden Square extension had replaced the car park and bus station with the new Hilden Platz next to the White Hart Hotel (left).

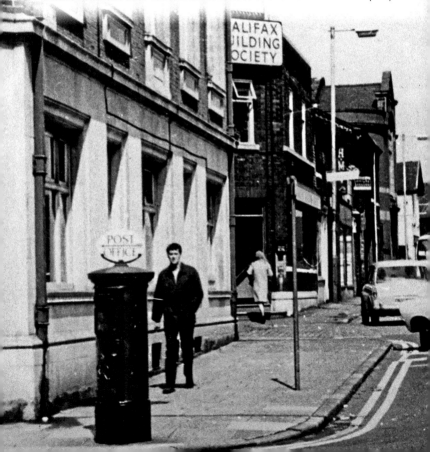

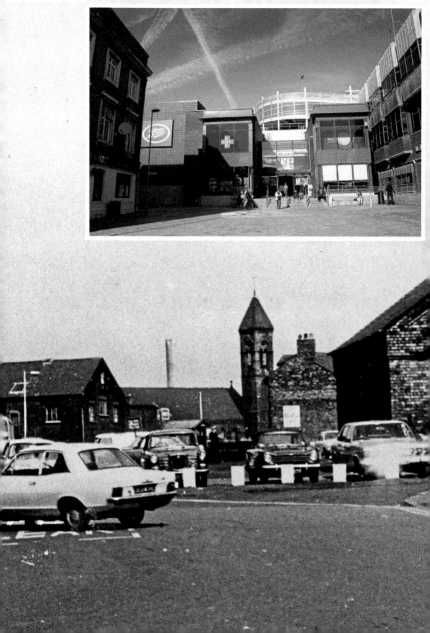

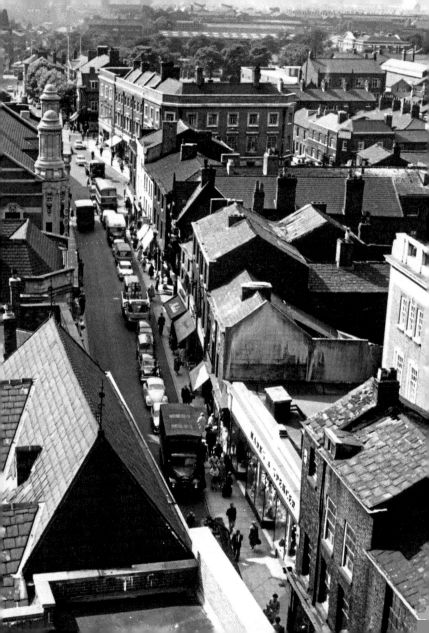

24. OLD SANKEY STREET

By the 1930s Sankey Street had been widened as far as the White Hart Hotel and plans were prepared to demolish the remaining premises on the right of this 1963 view from Holy Trinity Church tower. Marks & Spencer's store had been constructed in the 1930s with a false frontage in anticipation of the widening of Sankey Street to cope with the increasing volume of traffic. By the 1970s town planning favoured pedestrianisation of Sankey Street instead of road widening. In 1978 the original store – still with its temporary frontage – and its neighbours were demolished and a new Marks & Spencer's store opened in the first phase of Golden Square.

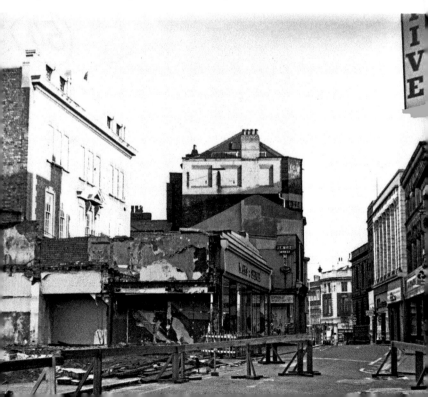

25. SANKEY STREET AT CAIRO STREET

Many long-established national businesses have recently disappeared from Warrington's main shopping streets with the advent of online banking and shopping. By early 2018 several key buildings near the junction of Cairo Street with Sankey Street stood empty, including the former Barclay's Bank (left). On the opposite corner of Cairo Street the imposing premises of the former Co-operative store had failed to attract a long-term tenant after first T. J. Hughes and Poundland departed. On 29 July 2017 Marks & Spencer deserted their Sankey Street base in favour of their Gemini superstore.

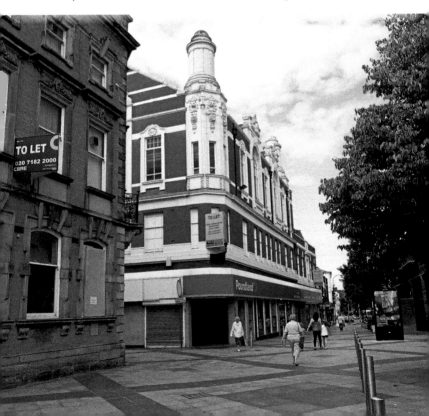

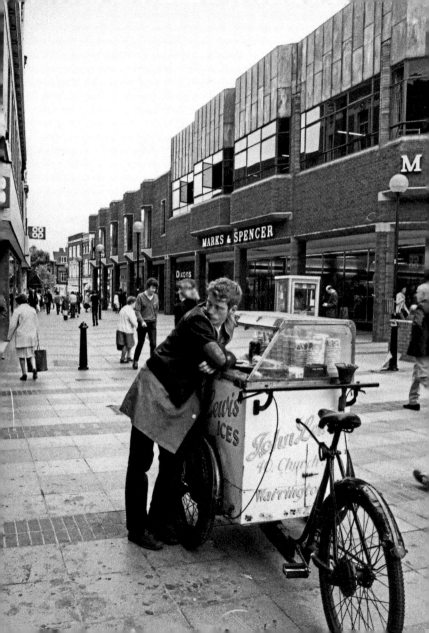

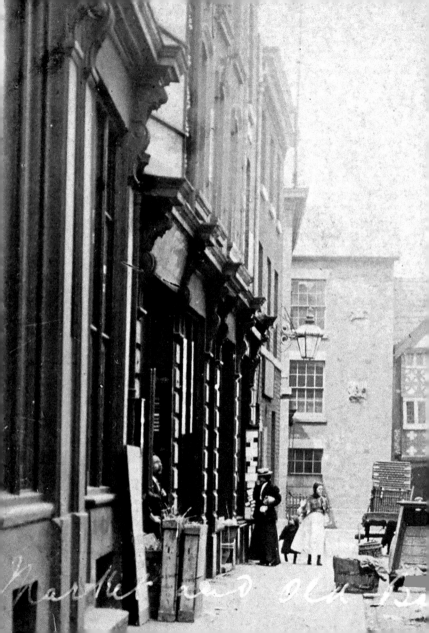

26. THE OLD MARKET PLACE, 1900s

Warrington's market dates back to at least 1277, and by the eighteenth century had moved off the main crossroad into Old Market Place. This 1900s view shows the open fish market built in 1856 where Mr Lee is selling oysters. In the background is the sixteenth-century half-timbered building traditionally known as the Barley Mow Inn.

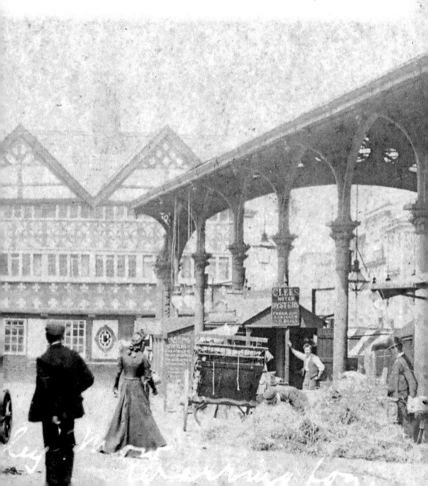

27. THE OLD MARKET PLACE, 2016

Already known as Golden Square by 1772, this area was home to Warrington's market until 1974. The decorative cast-iron structure of the old fish market was kept as a centrepiece when the area was redeveloped again in the 1980s. The Prince of Wales and Princess Diana marked the completion of Golden Square by unveiling the granite statue of the Mad Hatter's Tea Party on 30 May 1984.

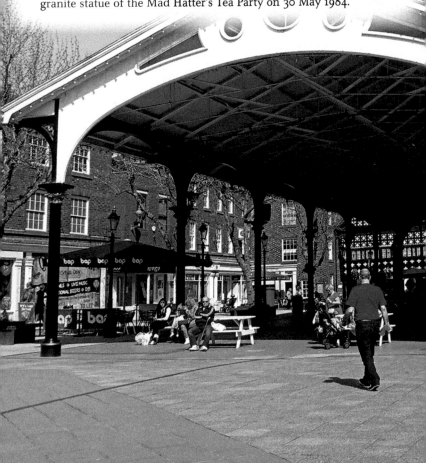

28. CHEAPSIDE

Those enjoying the café culture of today's Golden Square might suppose that many of the buildings surrounding them date from Victorian times or even earlier. This 1970s view from Market Gate (left) shows how much has actually changed in an area traditionally known as Cheapside. Like all of its neighbours the building in the background was demolished and rebuilt as a copy in the 1980s. However, an open space was created by the demolition of the imposing Italian-style Market Hall in the centre, which dated from 1856 as part of an earlier remodelling of the Old Market Place.

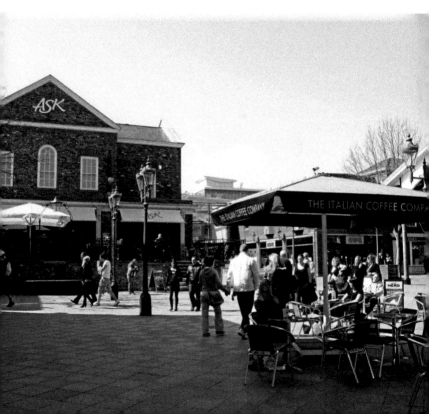

29. THE GUARDIANS

The corner of Sankey Street and Horsemarket Street was transformed with the building of the Golden Square shopping complex in the 1980s, but Market Gate lacked a focal point. Leading American artist Howard Ben Tre was chosen to transform the newly pedestrianised main streets between 2000 and 2002. Central to his designs is the Well of Light surrounded by ten abstract columns, or guardians, representing those who guard Warrington's heritage in the past, present and future.

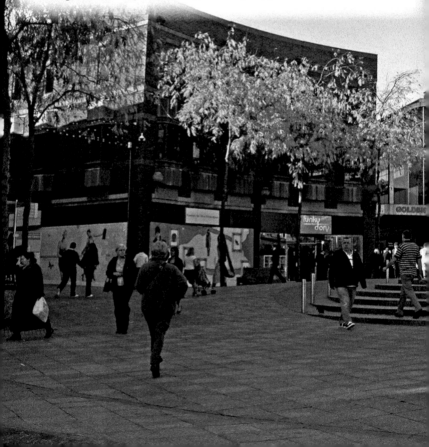

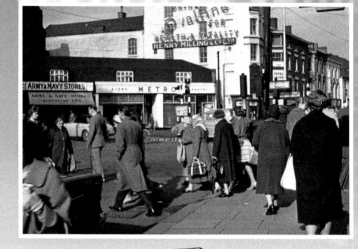

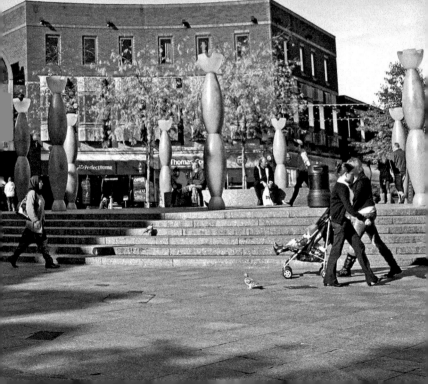

30. BUTTERMARKET STREET

The junction of Buttemarket Street and Bridge Street was the second portion of the Market Gate circus to be constructed in 1913–15. The street corner was considerably widened and built in a similar style to the adjacent corner with Sankey Street. Further changes, which took place in the later twentieth century, can be seen in the 1960s view (right) from Holy Trinity Church. Two cinemas on the left (the domed Empire and the art deco Odeon further down) are a reminder of earlier town centre nightlife. In the background are the factories of Cockhedge and Howley leading down towards Church Street.

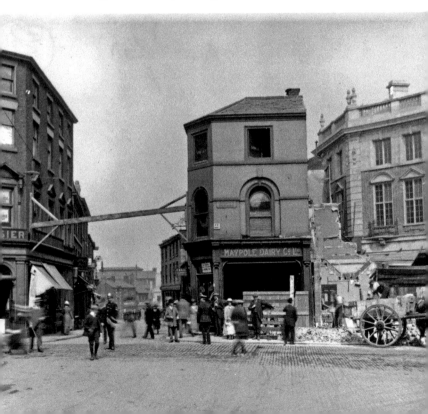

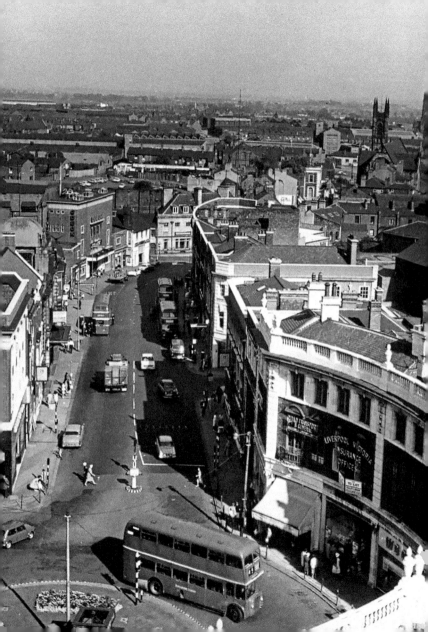

31. HORSEMARKET STREET TO WINWICK STREET

Horsemarket Street was partially widened in the 1930s by the rebuilding of the shops on the right-hand side of the main image, adjoining Buttermarket Street. The left-hand side was rebuilt in the 1980s during the first phase of Golden Square. At the beginning of the twenty-first century the street was pedestrianised and two water features added, including Howard Ben Tre's dramatic Well of Light.

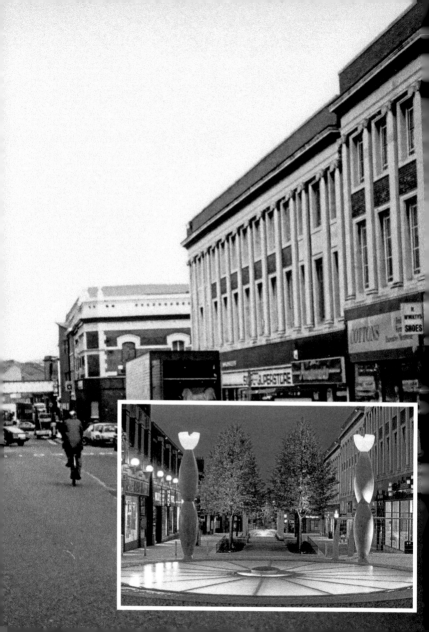

32. THE HORSEMARKET

Horsemarket Street really did once lead down to the site of the town's horse fair. This actually took place in the wide roadway of lower Winwick Street outside Central station (seen below.) Doubtless much of the horse trading took place in the numerous inns along the street. This postcard view probably dates from a few years after the last fair, which took place in 1911, as the era of the horseless carriage signalled the end of the annual market for work horses.

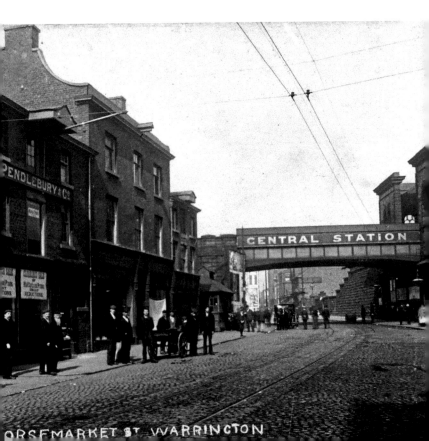

ORSEMARKET ST WARRINGTON

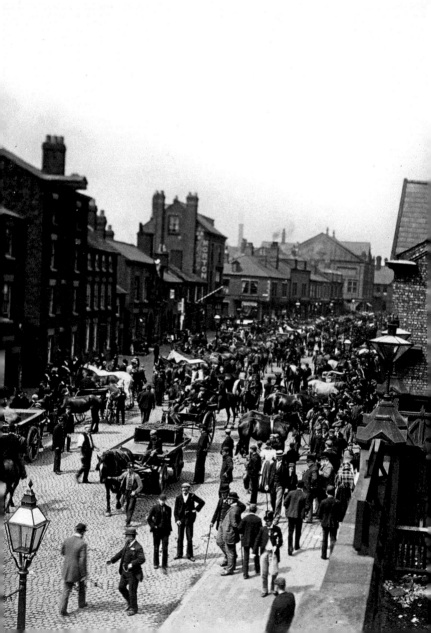

33. WINWICK STREET TO SCOTLAND ROAD

A number of architectural styles converge at this road junction. To the right is the futuristic bus interchange and on the near left the ornate Victorian façade of the Old Bank, once part of the National Westminster group. Next to the bank is a terrace of late eighteenth-century buildings. The former Theatre Tavern on the street corner used to serve patrons of the adjacent Theatre Royal in Scotland Road.

34. THE BUS INTERCHANGE SITE

The area where Horsemarket Street meets Winwick Street has seen dramatic changes over the last fifty years. The main 1970s photograph shows the premises at its junction with Queen Street and Bewsey Street, which were demolished during the construction of an inner ring road in the 1970s. In 2006 a second major upheaval saw the striking new Warrington Interchange materialise there to replace the Golden Square bus station.

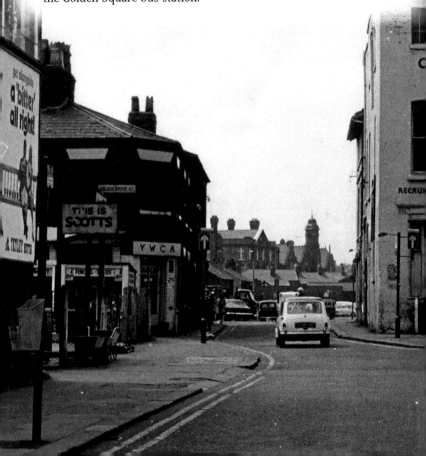

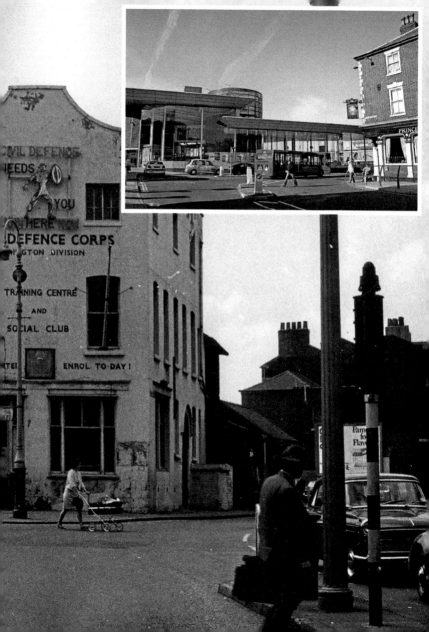

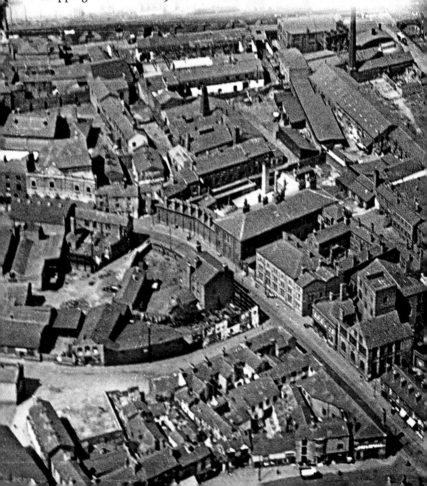

35. SCOTLAND ROAD

The area off Scotland Road known as Cockhedge has changed dramatically since this 1930s aerial view looking to Central station. Gone are the factories along the curve of Scotland Road and the chimneys of Cockhedge cotton mill (top right) were replaced by a shopping centre in the 1980s.

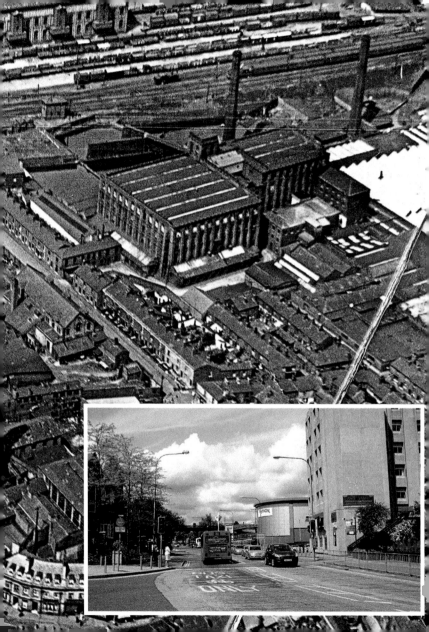

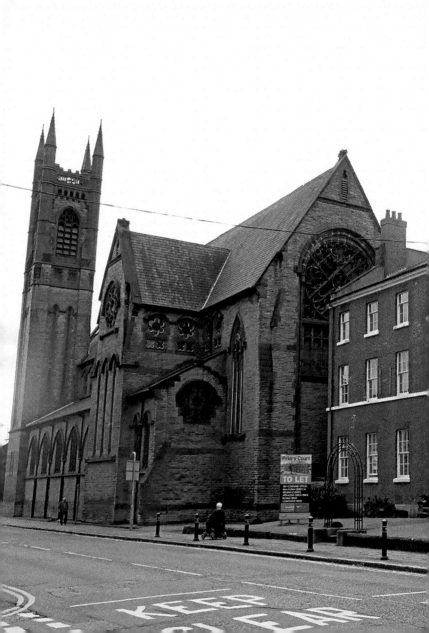

36. AROUND ST MARY'S CHURCH

By the mid-nineteenth century this part of Buttermarket Street was at the heart of a densely packed cluster of factories and working-class housing stretching from the rear of Bridge Street to Cockhedge. The white building opened in 1818 as a dispensary to provide medicine and outpatient care to the poor. In 1877 this was incorporated into the new site of St Mary's Roman Catholic Church with adjacent priest's accommodation and school. The Pugin interiors were complemented by the bell tower added in 1906.

37. CHURCH STREET FROM BUTTERMARKET STREET

At its southern end Buttermarket Street reaches a junction with Mersey Street (right) and today continues into Church Street across a busy roundabout where few pedestrians venture. In sharp contrast three small boys could lean casually on a lamp post in 1905 (inset) with only a tram and horse and cart passing leisurely by Downs's newsagent shop.

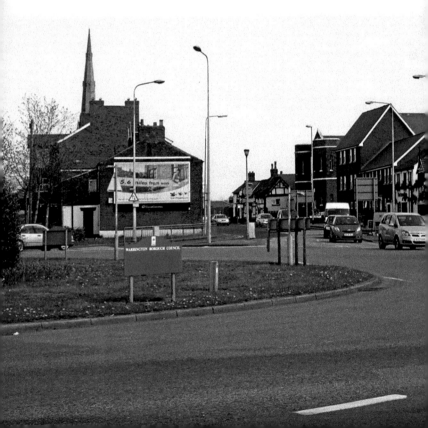

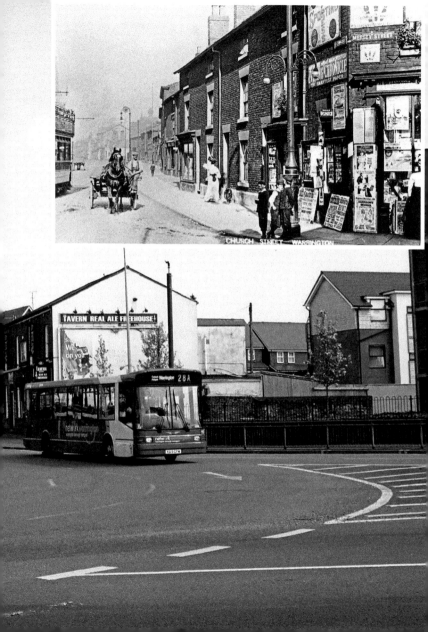

CHURCH STREET · WARRINGTON

38. CHURCH STREET

When local photographer Tonge produced this postcard of Church Street in 1906 many locals would feel it captured the sulphur fumes coming from the nearby wireworks of Lockers and Rylands. The image also shows the width of a street that was the original home of Warrington's market before it relocated to Market Gate after the building of the first Warrington Bridge in the thirteenth century.

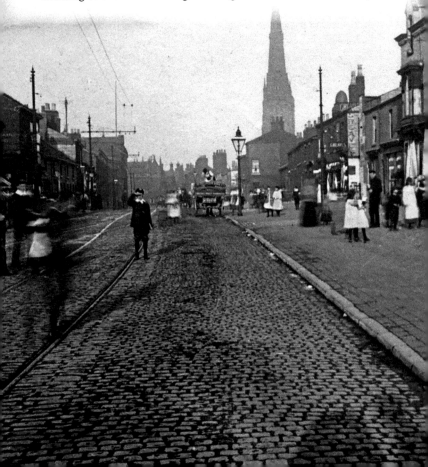

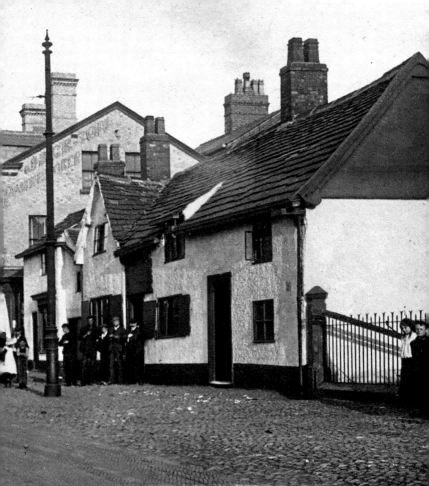

CHURCH ST WARRINGTON

39. NEAR THE TUDOR COTTAGE

A small child could safely play on Church Street's pavements in the early 1900s image on the right. Only two landmarks remain today: the parish church with its spire (right) and the black-and-white Tudor Cottage (near left). Rylands wireworks (to the right of the cottage) had arrived in Church Street around 1810 and within a century had become major employers exporting their products worldwide. Rylands and nearby Lockers wireworks disappeared with the late twentieth-century decline of the heavy metal industries, while the Warrington Training College (in the far distance), the terraced cottages, gas lamps and cobble stones have also vanished. Still dominating the street is Warrington Parish Church dedicated to St Elphin. Mentioned in the Domesday Book of 1086, it was extensively rebuilt in the 1850s–60s and has the third highest parish church spire in England.

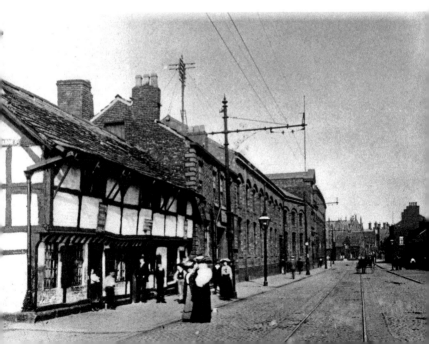

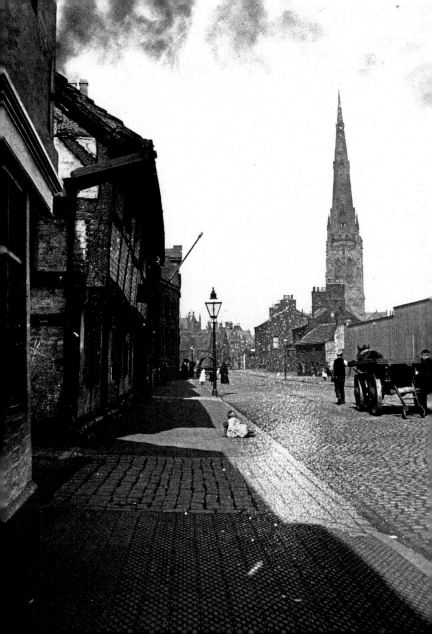

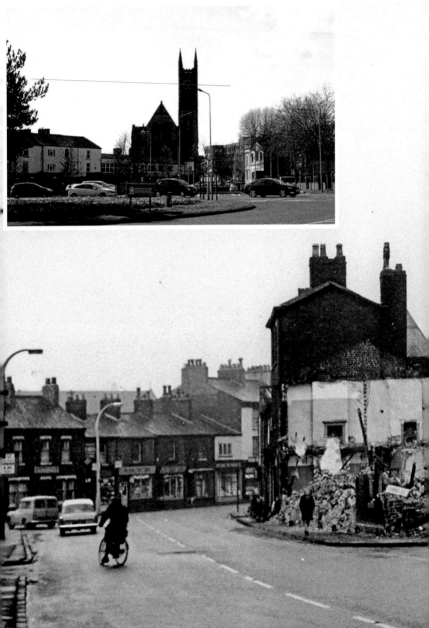

40. FENNEL STREET ROUNDABOUT

By the late 1970s the face of Church Street changed dramatically to accommodate the growing volume of traffic. The Co-operative store (right) and neighbouring premises made way for the new Fennel Street/Mersey Street traffic island, but St Mary's Church still provides a reference point in the changing streetscape.

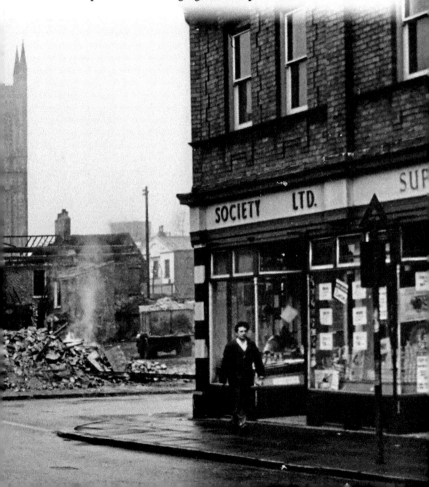

41. UPPER BUTTERMARKET STREET

This late 1970s photograph reminds us that Buttermarket Street was still a main bus route. Although the street is now landscaped for pedestrians, the buildings seem largely unchanged. Notice the group standing outside the tiny Tesco store that was crammed into the building second from the left prior to its move to hypermarkets at Irlam and Winwick roads.

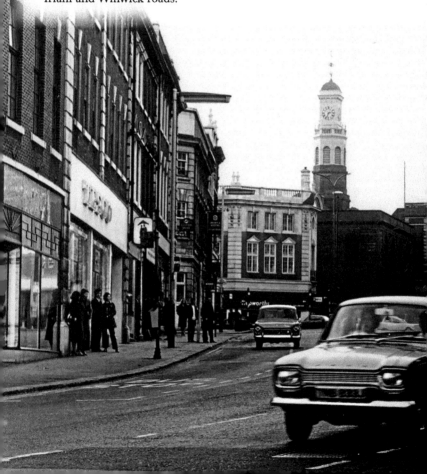

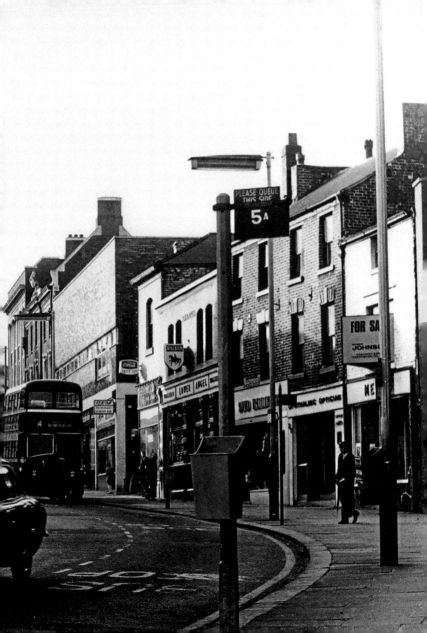

42. WARRINGTON MARKET

From the 1830s until the 1930s this area between Bridge Street and Buttermarket Street was home to migrant workers crowded into poor-quality insanitary housing. From 1974 to 2017 Bank Street was the site of Warrington Market following its relocation from Golden Square. By 2020 the medieval alley of Dolman's Lane leading into Bridge Street (to the far right) will become the site of Warrington's new permanent market.

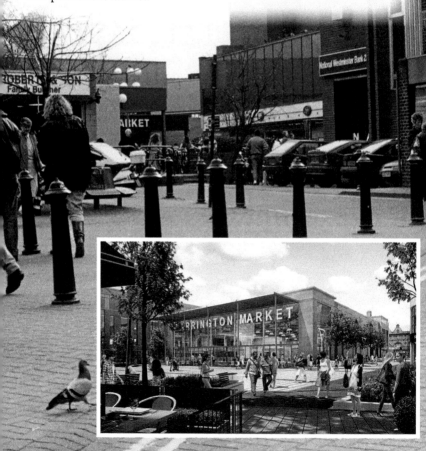

43. TIME SQUARE

Time certainly flies in this area of Warrington! Massey & Garnett's version of Time Square with its distinctive clock lasted barely thirty years after its completion in 1986. In September 2017 a temporary market opened in the building on the left in the first phase of building a new and larger Time Square.

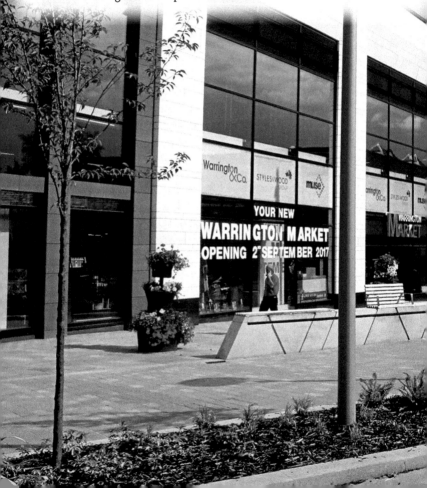

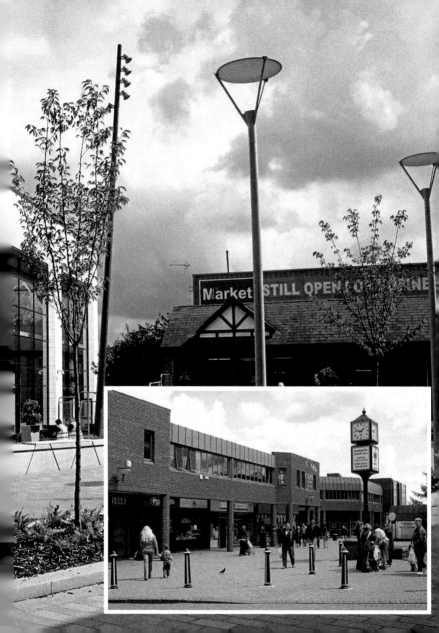

44. A NEW PARKING SPACE

In 2017 the townscape from Bridge Street along Academy Way began its second major transformation in forty years. The distinctive blue pedestrian bridge, the Market Hall (left) and the 1970s Mersey Street car park were swept away. Utilitarian concrete blocks gave way to a distinctive wire-mesh and chequerboard covered new addition to the town's skyline, which also provides an ideal viewpoint to watch the rise of Warrington's new centre.

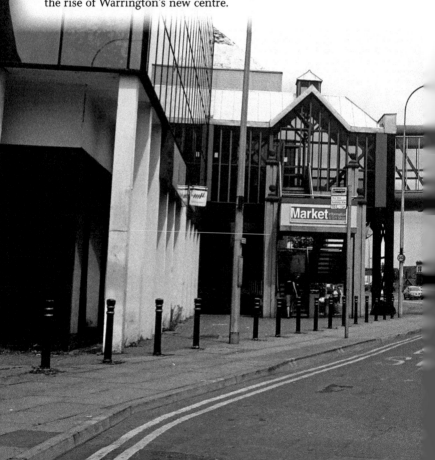